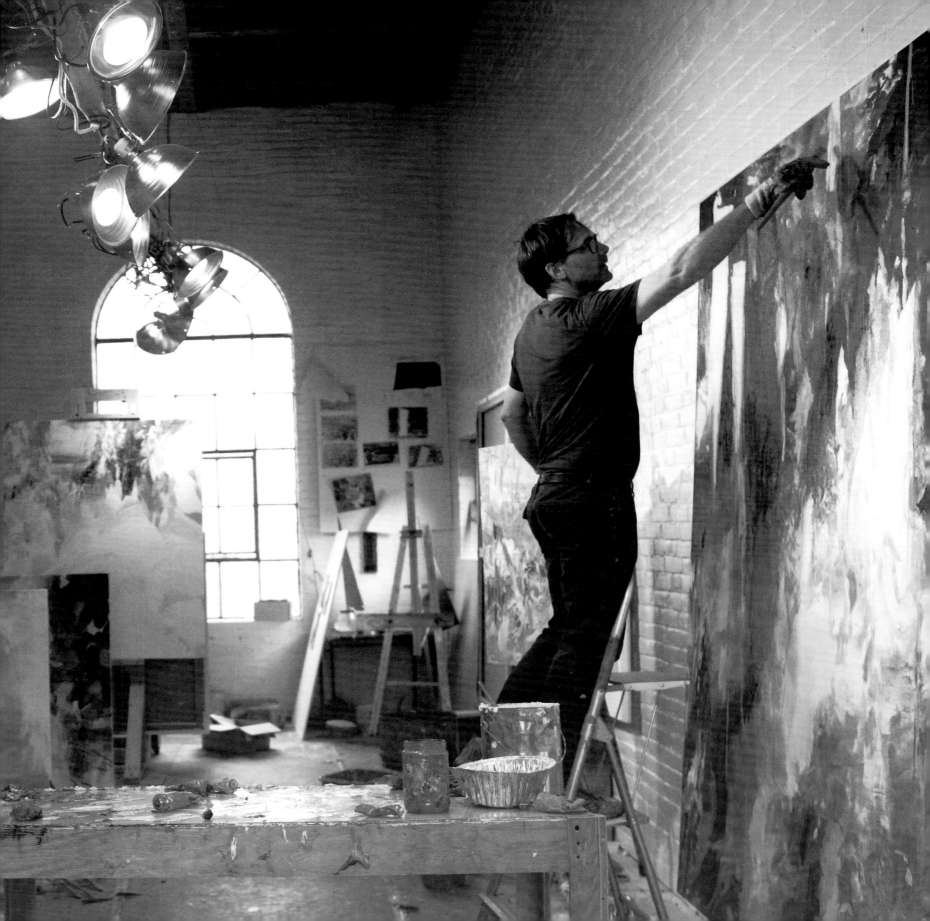

ERIC AHO

Translation

Essay by Diana Tuite

DC Moore Gallery, New York

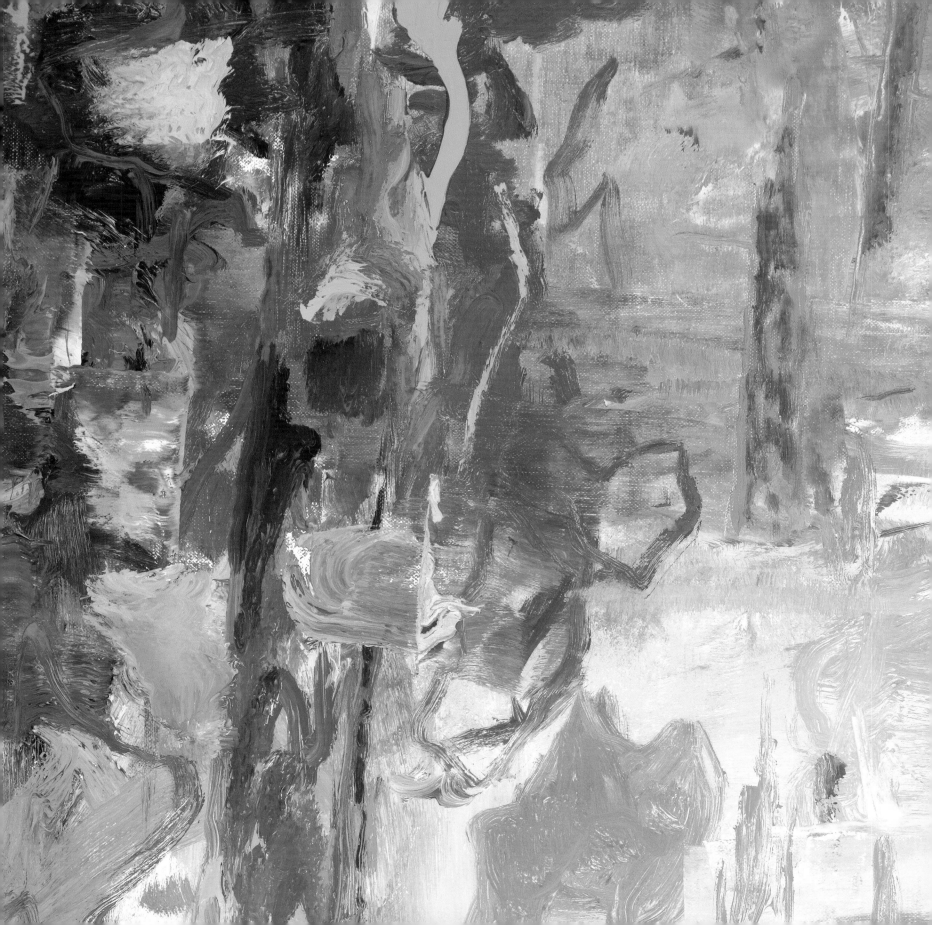

PAINTING CLOSE IN

Nature does not proceed in a straight line, it is rather a
sprawling development. Nature is never finished.

—Robert Smithson

"I'm in it." So Eric Aho characterizes his submission to any canvas on
which he is working. And his presence remains irreducible. Formerly a
plein-air painter whose gaze alighted less and less on the motif, Aho
opted to go deeper by means of withdrawing. By this I mean not only
that he moved indoors, but that he has begun to paint with cumulative
and embodied knowledge of his subject rather than studying it at arm's
length. Whether he is responding to primary sense memories of his own,
or overlaying those with other subjectivities (his father's, for instance), he
paints with a knowing interiority.

In the onrushing vicissitudes of the paint handling, Aho's paintings share
a fluidity with the natural world, while simultaneously exploiting their
adjacency to it. As he explains, "You have to be in the painting and in the
woods at the same time." It is from within this proximate zone that one can
appreciate the white "as paint, as light, as nothing." As he sees it, his task is to
present immediacy remembered, to reconcile directness with retrospection.
How might the experience of the painting reciprocate the experience of that
which it depicts? It is in the coexistence of interiority with approach, the
feeling of being a part but also *apart*, that Aho's recent landscapes are most
congruent with our optic and haptic experience of the outdoors.

CANADA (detail), 2013
Oil on linen, 48 x 60 inches

These paintings have their genesis in compositional challenges that the artist sets forth, many of them carried over, unfulfilled, from his plein-air practice. How, for example, might one represent a dense forest as something other than merely a collection of trees?[1] How can one translate simultaneous waves of sensation across a continuous pictorial surface? More than that, how does one register the crosswinds of sensory integration in the form that one gives a single tree? A tree might, for example, manifest as a spray of pink horizontal dashes, a spinal column of sorts, drifting across scumbled blue (*Ravine Pool*, page 57). Or it may emerge from a few daubs whose interstices describe dappled light wrapping the surface of a trunk (detail of *CANADA*, page 2) As Aho reminds us, "You can't paint the entirety of that tree because it exists only in a blink." This feeling of instantaneity is particularly striking in *Wilderness Studio* (page 33, page 4-5 detail). Here, prismatic tree trunks shudder, glinting with suggestion and, in places, dipping deep into erasure. Even as they root us in the terrain, they absorb their surroundings to such an extent that they warp the area around them.

Through just such pictorial elisions, Aho acknowledges the insufficiencies of vision, and also, crucially, the ways that recognition can abridge our observations. After all, he condenses cursory encounters and sustained analyses in these paintings, burnishing each with the imagination's digressive tendencies. This powerful amalgamation recalls a diary entry in which Pierre Bonnard, an artist who painted entirely from memory, noted succinctly: "Consciousness, the shock of feeling and memory."[2] With this ambiguous parataxis—a construction that either juxtaposes consciousness with feeling and memory, or posits them as its texture— Bonnard suggests the rupturing forces of sensation and remembrance at work in Aho's paintings.

Whatever their occasioning impulse, Aho's paintings eventually "tip into being real," as he says, disclosing their own internal topographies and

displacing his motivations. This interpretive mapping requires a balanced touch and enough sensitivity to let the composition settle in where necessary and to muscle things in elsewhere until a dynamic equilibrium is achieved. When Aho puts down a definite mark, for example, it may be followed by a color "approximating what has been seen and remembered," with each further remove then countered by other specificities. This push-pull continues apace until the painting has revealed itself to him.

The sky is halfway still, half wild;
half it is involved with cloud,
half stepping brightly out in blue.

—Robert Walser, "White Linen"

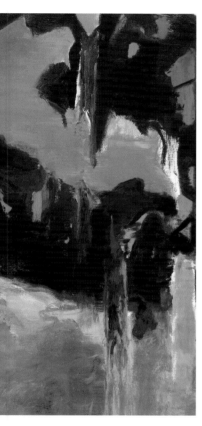

Wilderness Studio (detail), 2013
Oil on linen, 62 x 80 inches

Although a number of his titles draw on the authoritative rhetoric of the "approach," or the "trail," Aho values what might be gained through indirection. This is the reason that he so enjoys filtering the consciousness and visceral experiences of other individuals through his own. By superimposing multiple habits and histories of perceptual access in this way, he can comprehend correspondences, deviations, and frictions, and he begins to represent a landscape intersubjectively. In title and in appearance *Translation* (page 47) evinces this layered technique. Certainly the scattered white and pale blue marks feel as though they exist on top of the glass fronting a whole other image. Much like the act of linguistic translation can incur greater clarity and precision or, alternatively, loss, *Translation* yields a range of encounters.

Nowhere are the many refractions that Aho performs more evident than in those paintings based upon his father's recollections of the Second

World War. Shards of impressions that his father collected during bouts of waiting or marching through the French countryside have induced instinctive empathy in him. These paintings show him casting himself into recollections which are not his own and which remain lodged within spaces of tremendous violence, never facing directly back onto it. In *Outside Paris in August* (page 6), for example, he evokes the blond light that one sees especially in Edward Hopper's early Parisian scenes (page 6), particularly in its tarnished greens and lavender shadows. Like Hopper, Aho implies an expansive vista with a dash of road. But, whereas Hopper was interested in the stratification of the terrestrial field, Aho is preoccupied with a canopy of sky in tumult. Might one take this as smoke from a skirmish drifting across the plain? Certainly the acidic greens combine with his barbed strokes to electrify the atmosphere. And one cannot ignore the bright red dot of paint that has not been completely swept into the horizon. Nor can one dismiss the coarse brushwork and the rawness of the various pinks that tussle with black in *Troyes* (page 6).

This persistent tension between interiority, with the access it affords, and proximity, with the pressure it delivers, is also present in Aho's relationship to his artistic forebears. In fact, without consciously realizing it, he appears to have been circling one painting in particular: Diego Velázquez's *The Spinners* (page 7). It is, incidentally, a painting that he just this year visited in person, at Madrid's Museo del Prado. Originally entitled *The Fable of Arachne*, this painting depicts, at front, women in whirring motion as they spin and card wool. Velázquez obscures a number of their faces, as though to signal their degree of focus. Outwardly, this is a representation of a tapestry workshop, but, as numerous scholars have gone to lengths to establish, its subject is more the entwining of diverse citations.[3]

Beyond the foremost scene one beholds further pictorial refusals that warrant holding this painting up alongside Aho's recent work. In what appears to be an architecturally discontinuous chamber Velázquez staged

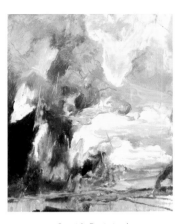

Outside Paris in August, 2013
Oil on wood panel, 20 x 16 inches

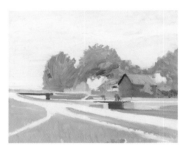

Edward Hopper, *Canal Lock at Charenton*, 1907. Oil on canvas, 25 ¼ x 28 1/8 in. Whitney Museum of American Art, New York; Josephine N. Hopper Bequest 70.1227.

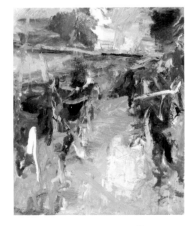

Troyes, 2013
Oil on wood panel, 20 x 16 inches

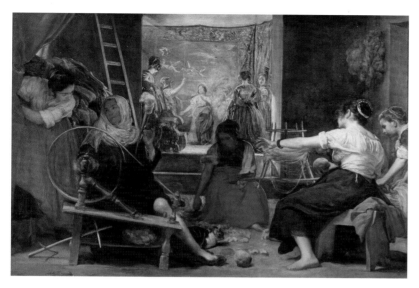

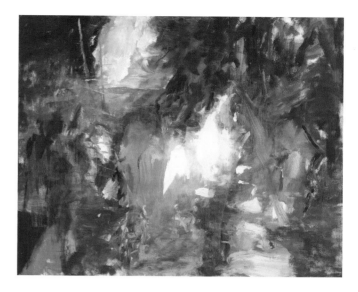

Diego Rodríguez de Silva y Velázquez, *The Spinners,* or *The Fable of Arachne,* ca. 1657.
Oil on canvas, 86 5/8 x 113 3/4 in. © Madrid, Museo Nacional del Prado.

Interior, 2013
Oil on linen, 30 x 36 inches

a self-contained episode accentuated with auroral light. Just in front of, but also curiously merging with, a tapestried wall is what one may recognize as the mythological confrontation between Athena, with arm raised, and Arachne, the mortal weaver whose boasts would precipitate her transformation into a spider. Acknowledging the spatiotemporal irreconcilability of the painting's two events, art historian Svetlana Alpers has written of their relationship: "It is better not to describe it as far and near. It is rather the juxtaposition of the large and the small."[4] This recasting of perspectival relativism as synchronicity is something well worth holding onto when considering Aho's work.

The Spinners resonates coloristically, rhythmically, structurally, and even thematically with *Interior* (page 7), a departure from Aho's more prevalent vertical format. Here, roughly at the center of the pictorial field, is a brilliant and jagged flash that evokes a hollow or clearing which, paradoxically, projects itself forward. This passage exerts centrifugal power as it overwhelms the intervening trees. In spite of the white paint's visibility, the impression of

this effulgence as a source from which all of the other marks emanate is so strong that one is almost tempted to read it as canvas left in reserve. Just as the fantastically lit and yet inscrutable action of *The Spinners* occupies what appear to be both the focal and the vanishing points of the painting, this incandescence presents an aporia.

Such elements represent the further development of what critic Donald Kuspit characterized as the "slab of light" present in Aho's Covert series.[5] Those taut and discrete (and, by extension, modernist) forms have now relaxed, manifesting less like symbols and more like the enigmatic episode that governs *The Spinners*. Indeed, *Interior* seems organized around this luminous event and other whites are woven, weft-like, throughout. Spatial and phenomenal, this central white passage swings between occlusion and illumination. In *Mountain Approach IV* (page 10), a similar form appears as a less autonomous entity. Here surrounding brushwork subdues it, making the surface appear to drape off a single plane. This shallow and undifferentiated field achieves the equidistance that one sometimes feels when one is immersed in nature and, more than ever, apprehends one's distinction from it. *Trail (Third Approach to the Mountain)* (page 19) borrows the seething silhouettes of Aho's earlier fire paintings for its numinous whites. Voided, but also surging, they seem to figure both presence and absence.

However ambiguous its relationship to the spinners, the space at the heart of Velázquez's painting serves to introduce two genealogies, one for the laboring subjects, in the form of the mythological weaver, and one for the artist himself. By reinterpreting a (now lost) painting of Minerva and Arachne by Peter Paul Rubens, the foremost artist of his day, Velázquez asserted his own artistic vision. Setting this scene against a mounted tapestry inspired by Titian's painting *Europa* (now in the Isabella Stewart Gardner Museum), executed a century before, he compounded the statement.

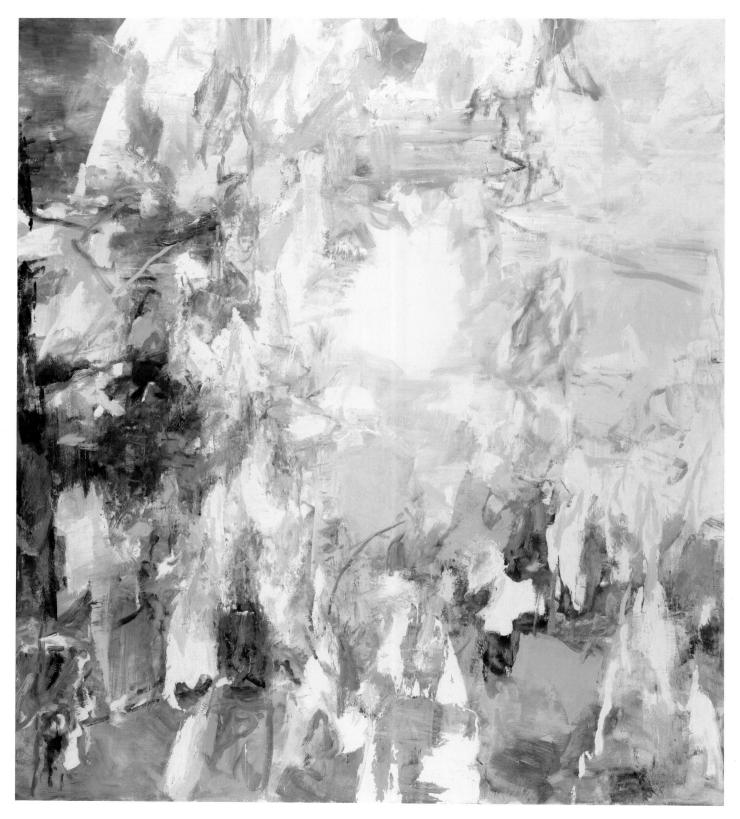

Descendant, 2013. Oil on linen, 92 x 80 inches

Similarly, *Interior* contains that which might be considered anterior to it. At the upper left, as though spied through the isolating cylinder of a telescope, it is possible to glimpse rolling hills shrouded in *sfumato*. This familiar shorthand offers a reprieve from the direct sensory experience of Aho's stand of woods. Where the trees part, a patch of sunlit sky is visible, its warmth a foil to the cold radiance of the forest depths. Elsewhere, a hazy vista coalesces in a few dashes of yellow paint (*Descendant*, page 9), the horizontal direction being something that the artist employs only sparingly. In *Migration* (page 23, page 25 detail) the foreground brushwork is so heavily encrusted as to seem almost optically impenetrable, and yet the contour of a hillside and a horizon line survive in what resembles a trace underdrawing.

Son (detail), 2013
Oil on linen, 48 x 60 inches

Such vestiges of landscape tradition persist in suspension throughout Aho's recent work, carrying with them associations to his past practice. When they appear, they do so as figments that may just as easily be said to rationalize the composition as to trouble it. Whatever form they take, these allusions humanize Aho's representations of the outdoors, infusing them with consciousness and, most importantly, memory. Tucked into the upper right-hand corner of *Son* (page 45, page 10 detail), for instance, floats an expanse of mountain and valley whose palette necessarily recalls Paul Cézanne's depictions of Mont Sainte-Victoire. Painting, like nature, is a site of cumulative action and consequence.

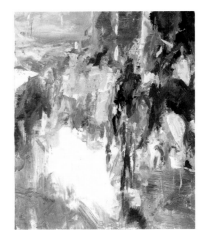

Mountain Approach IV, 2012.
Oil on wood panel, 20 x 16 inches

Returning, for a moment, to *The Spinners*, it is worth noting that Velázquez's painting suffered from the muting of its iconography as time passed; knowledge that the figures represented Athena and Ariadne was lost (hence the title's shift of emphasis) and they were only reidentified as such in the 1940s. As was previously discussed, the painting internalizes its ancestry, but as a historical object, too, it embodies lapses of cultural

memory and layers of projection not unlike the distortions that Aho seeks to accrue. A metaphorical tapestry, therefore, at the level of both image and endeavor, *The Spinners* begins to offer us a way into further consideration of Aho's paintings.

My body is a thing amongst things, it is caught in the fabric of the world.

–Maurice Merleau-Ponty

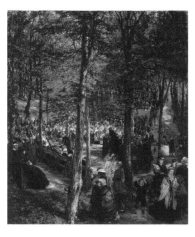

Adolf Menzel (1815–1905), *Sermon in the Beech Grove near Kösen*, 1868. 27 15/16 x 22 13/16 in. Museum of Fine Arts, Budapest.

In reflecting on some of the ways that Aho charges his landscapes with figural presence, it may be instructive to examine a painting that induces our blindness to the many figures who do not, in fact, serve as its animating force. Working within the Northern European landscape tradition to which Aho looks, German artist Adolph Menzel in 1868 depicted a congregation gathered within a natural amphitheater in *Sermon in the Beech Grove near Kösen* (page 11), now in the collection of the Museum of Fine Arts, Budapest. Having sketched the trees and benches on site, he later introduced the flock. What is extraordinary about this painting (one that Menzel categorized as "adapted from memory") is how much it honors the sketch in terms of the placement and density of the trees even as the artist insinuated the crowd into the spaces encircling them. Rather than show us a forest shot through with rays of sunshine (this would perhaps be at odds with the verticality of the woods and the eddying churchgoers, not to mention being symbolically overwrought), Menzel dwelt on the objects of that light. By kindling tree trunks, patches of earth, and swatches of clothing, he created what remains a poignant study of the woods; the curious human vignette feels only incidental.

Whereas Menzel contrived a landscape in which interloping human activity is secondary, Aho inscribes figural relationships directly into the landscape. That is not to say that he anthropomorphizes its features, but rather that, by a transitive logic, his marks carry metaphorical vitality and description. Given his capacious art-historical appetite, it comes as no surprise that Aho has crystallized his goals for establishing the "sensation of the figure/ human presence" through a study of Titian's *The Bacchanal of the Andrians* (page 12). Another of the Prado paintings that he saw firsthand this spring, it belongs to a genre invested in the hedonistic return to a pagan state and the physical dissolution of boundaries so entailed. Here Titian underscored this in the degree to which figures become entwined with tree trunks, or, in the case of the supine male on the hilltop, withdraw from society altogether and slump into the fecund earth.

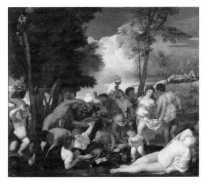

Titian [Vecellio di Gregorio Tiziano],
The Bacchanal of the Andrians, 1523–1526.
Oil on canvas, 68 7/8 x 76 in.
© Madrid, Museo Nacional del Prado.

"I immediately responded to the way the tangle of figures fills the entire bottom half," Aho noted about *The Bacchanal*, "They are the landscape—the natural world." In his *Spanish Landscape (After Titian)* (page 12) one cannot help but discern concentrated torsional energy in the foreground and intuit in it the rhythmic entanglements of limbs and glances seen in *The Bacchanal*. This flutter of figural marks surrounds a rush of grey paint, something that enhances the sense of introversion, bringing this assembly perhaps closer to Cézanne's bathers, with their inchoate ceremonialism, than to Titian's more presentational ensemble. Aho accomplishes all of this not by working in reverse from figuration to abstraction, but by repurposing his facture, and aspects of *The Bacchanal* become clarified through his response. The nude nymph at right, for example, appears to have succumbed to the potent wine, but she also serves a more pragmatic function; her marmoreal form contributes to the cadence of light and shadow. In *Spanish Landscape* Aho instead uses an achromatic palette and what feel almost like contour lines to call out shapes from within the whites.

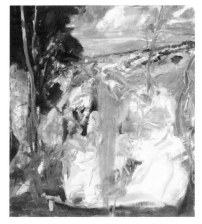

Spanish Landscape (After Titian), 2013
Oil on linen, 36 x 30 inches

With its bold greens and blues, *Spanish Landscape II (After Titian)* (page 69) reinstates some of Aho's allusions to the coloration of Willem de Kooning and Richard Diebenkorn. The arid hillside at right is once again intact; it anchors each of the pieces in this series. Comparatively vacant in the center foreground, this canvas channels the more explicit figuration of the earlier painting back into the landscape. The brushwork is now more integrated and the gestural activity and color in the trees at left are heightened. This sense of withholding becomes even more pronounced in *Antonello* (page 53, page 13 detail) and *Spanish Road* (page 13). Inspired by a hermit who had given himself over to the countryside outside Granada, the former work exploits a range of techniques for turning and articulating tree limbs. Without treating them analogously, Aho nevertheless manages to coax out the inference of a "human presence."

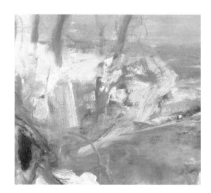

Antonello (detail), 2013
Oil on linen, 36 x 30 inches

A landscape does not sink into you all at once.

–Claude Monet

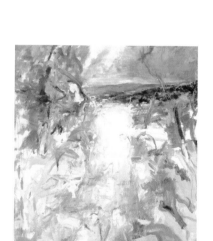

Spanish Road, 2013
Oil on linen, 36 x 30 inches

"You have to be willing to jettison the device," Aho has said of the conclusion of his fire paintings, a series incited by the cyclical brush fires undertaken in fields near his studio. From these he moved on to the most overdetermined of natural phenomena, the twilight scene. It is as though the phenomenal clarity of the fires emboldened Aho to confront the specificity of dusk, and our cultural tendencies to interpret such images as ciphers for environmental anxiety. In Aho's *Twilight (25 February)* (page 14 detail) sunlight has, for the most part, been exhaled from the forest. What remains is a silent precariousness that recalls the very sparest of J.M.W. Turner's sanguine sunsets (*Sunset*, page 14).

Once the light evacuates, what moves into its place? For decades Aho has contemplated doing a series of firefly paintings, conceiving of the insects as "a constellation that has settled here on earth." And so *Sebago Firefly* (page 15) conjoins the celestial with the earthbound, the spirit of nocturnes by James Abbott McNeill Whistler with the solidity of those by Alex Katz (page 15). One is persuaded of the forest's substance even as one is able to exhume each of the strokes of paint that the artist has put down in rendering it. The "shock of space," as Aho expresses it, is both his impetus and his ambition. Shock, of course, may result from a sudden and jarring disorientation or from the steady burning spark of something familiar. In Eric Aho's cosmos one finds both.

Diana Tuite
2013

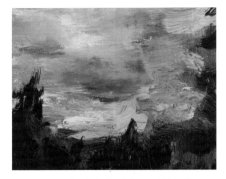

Twilight (25 February) (detail), 2013
Oil on linen, 22 x 24 inches

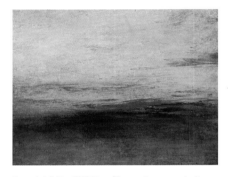

Joseph Mallord William Turner (1775-1851), *Sunset*,
c. 1830-5. Oil paint on canvas, 26 1/4 x 32 1/4 in.
©Tate, London 2013

1 Quoted in P. Andrew Spahr, "Transcending Nature," in P. Andrew Spahr et al., *Transcending Nature: Paintings by Eric Aho* (Manchester, NH: Currier Museum of Art, 2012), 20.

2 Quoted in Rika Burnham, "Intelligent Seeing," in Dita Amory, *Pierre Bonnard: The Late Interiors* (New York: Metropolitan Museum of Art, 2009), 72.

3 See most recently Svetlana Alpers, *The Vexations of Art: Velázquez and Others* (New Haven: Yale University Press, 2005).

4 Alpers, 138.

5 Donald Kuspit, "Sublime Fullness, Perennial Light: Eric Aho's Paintings," in *Eric Aho: Covert* (New York: DC Moore Gallery, 2011), 12.

Diana Tuite is an art historian and curator specializing in modern and contemporary art. Just appointed as the inaugural Katz Curator at the Colby College Museum of Art, she will be commencing work on a number of exhibitions. Previously, as the Mellon Curatorial Fellow at the Bowdoin College Museum of Art, Ms. Tuite organized major exhibitions of work by Edward Hopper, William Wegman, Lesley Vance, and Todd Webb. In collaboration with the Yale University Art Gallery she also curated "Methods for Modernism: Form and Color in American Art, 1900–1925." Ms. Tuite has taught art history at the City University of New York and the Maine College of Art, and has contributed to an array of publications. She holds a B.A. from Yale University and an M.A. from Princeton University, where she is completing her doctorate.

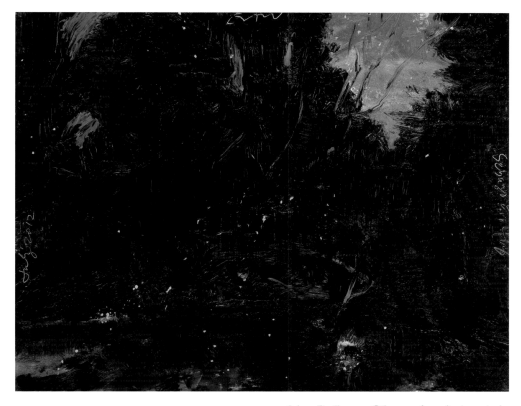

Sebago Firefly, 2012. Oil on wood panel, 16 x 20 inches

Alex Katz, *East*, 1987.
Oil on canvas, 125 3/4 in. x 288 3/8 in.
Colby College Museum of Art. Gift of the Artist. 1995.041

PLATES

Trail (Third Approach to the Mountain), 2013
Oil on linen, 92 x 80 inches

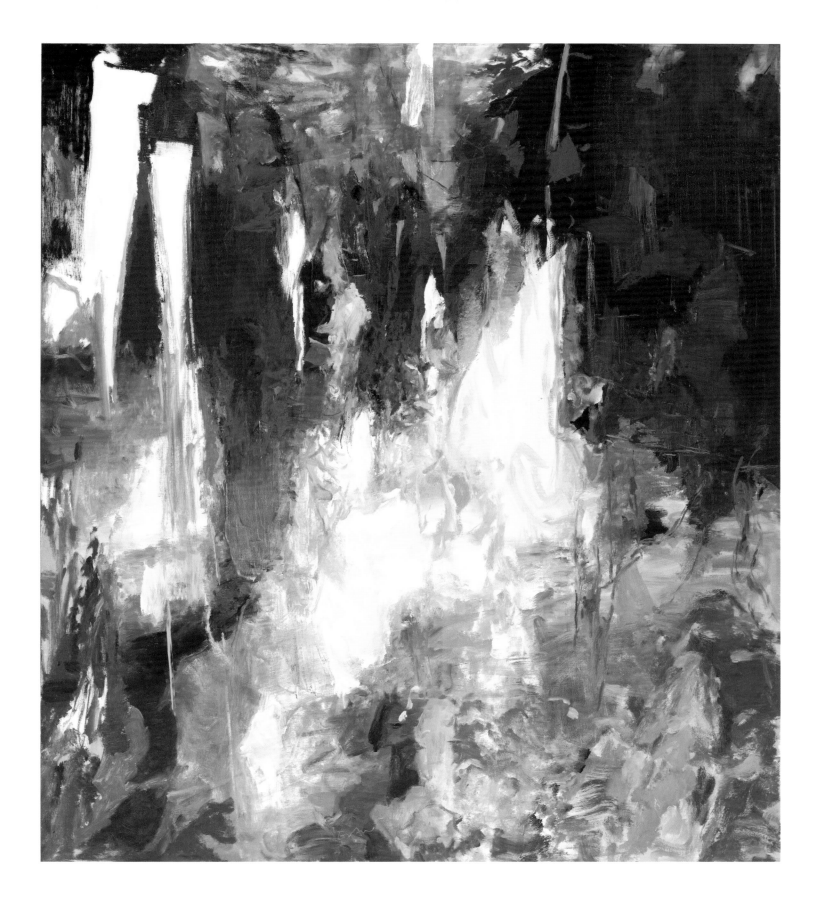

Approach, 2012
Oil on linen, 108 x 92 inches

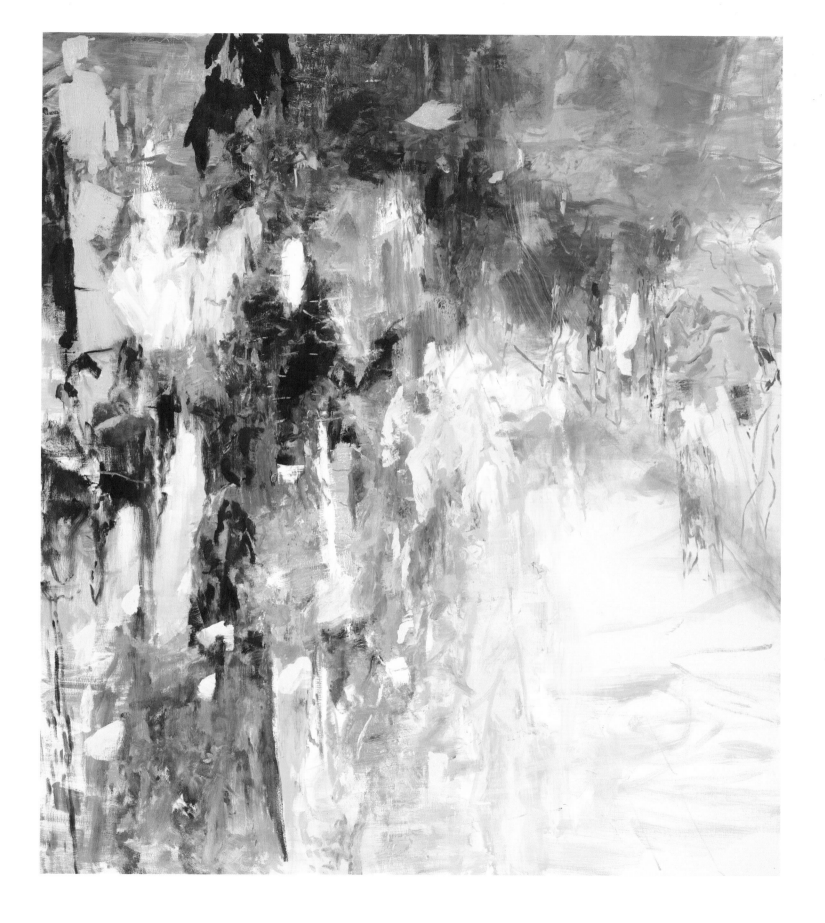

Migration, 2012
Oil on linen, 76 x 56 inches

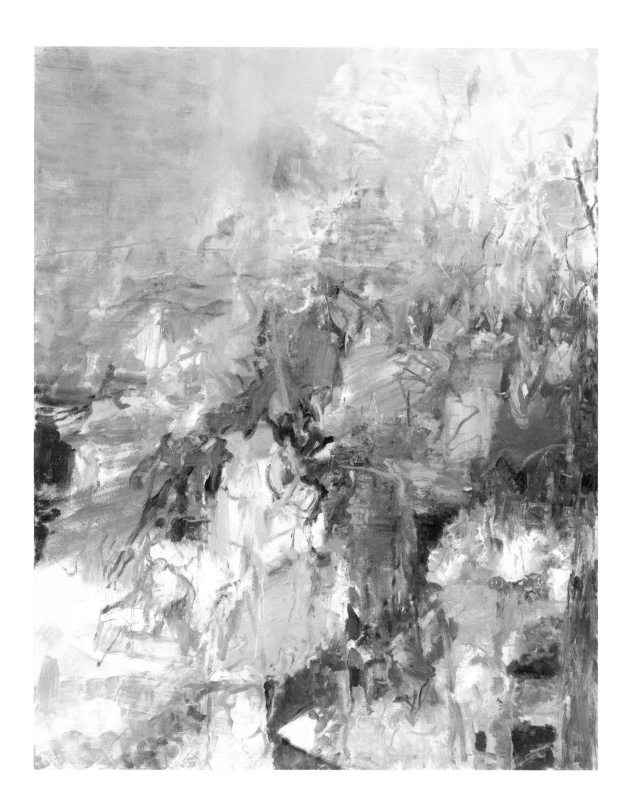

Migration (detail), 2012
Oil on linen, 76 x 56 inches

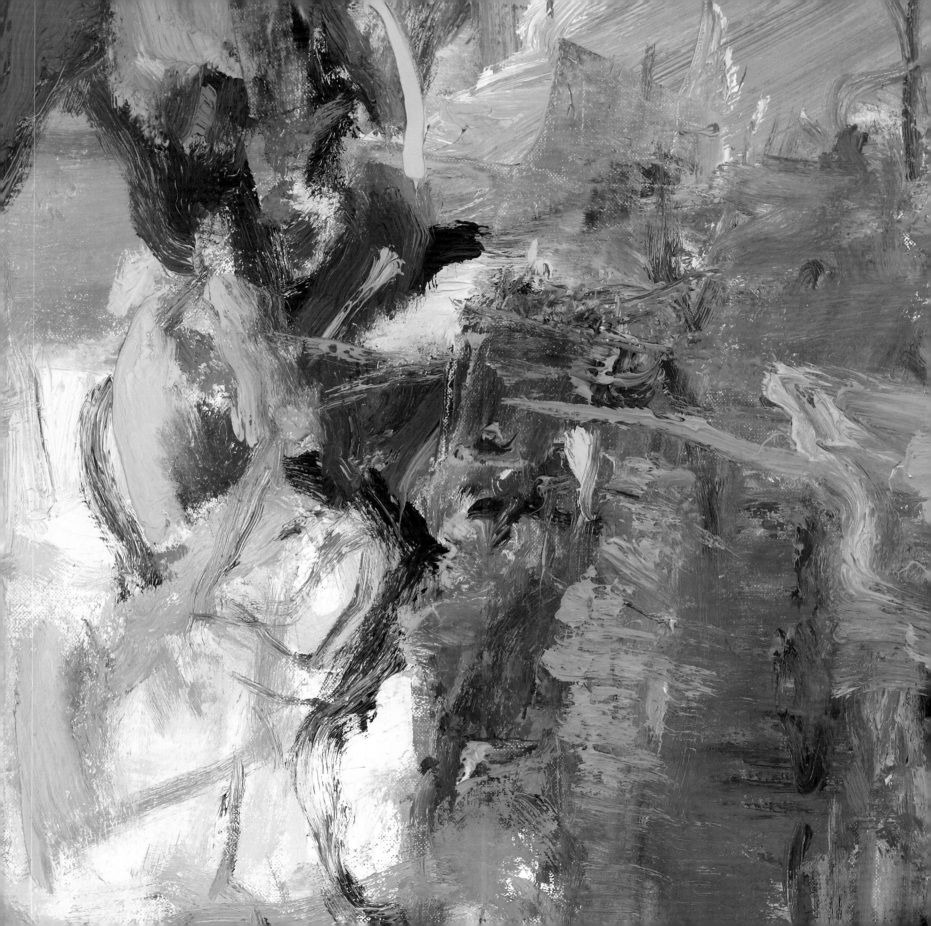

November November, 2012

Oil on linen, 76 x 56 inches

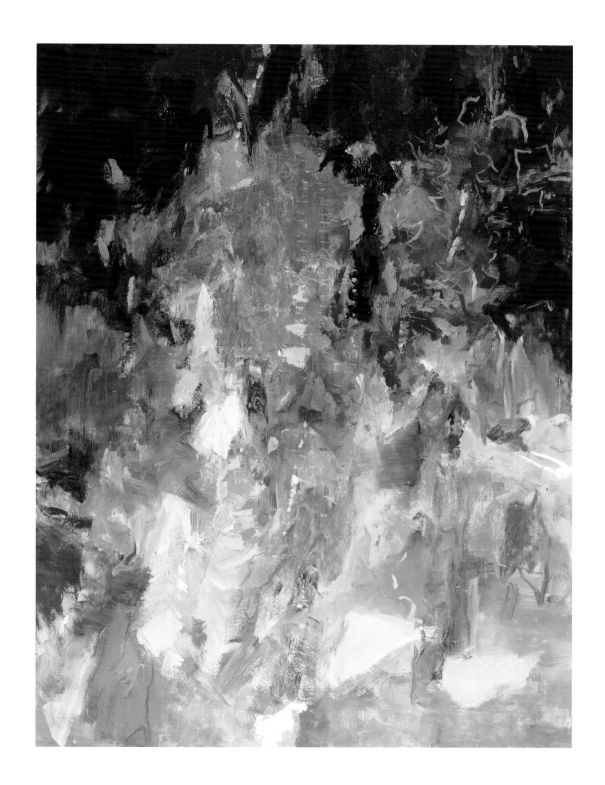

CANADA, 2013

Oil on linen, 48 x 60 inches

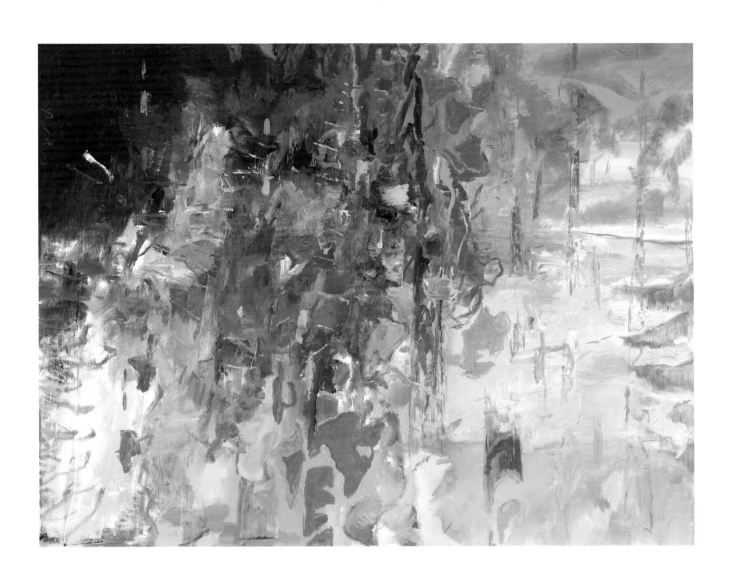

Wilderness, Twilight, 2013

Oil on linen, 48 x 60 inches

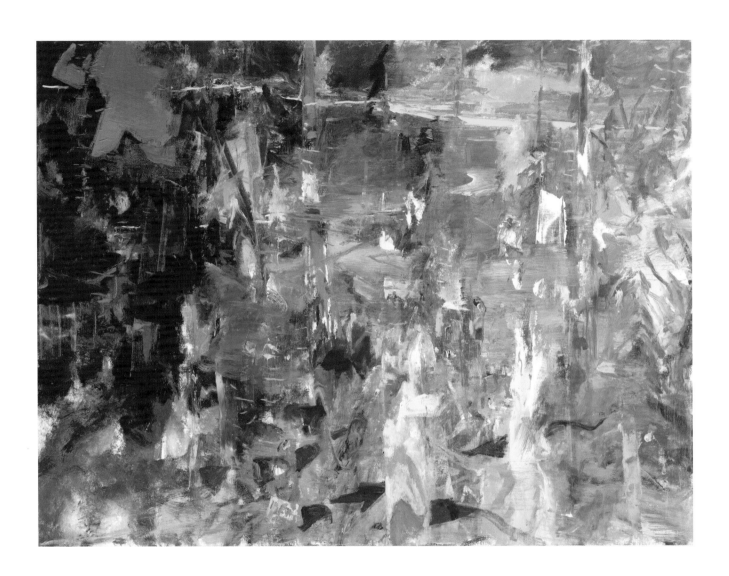

Wilderness Studio, 2013
Oil on linen, 62 x 80 inches

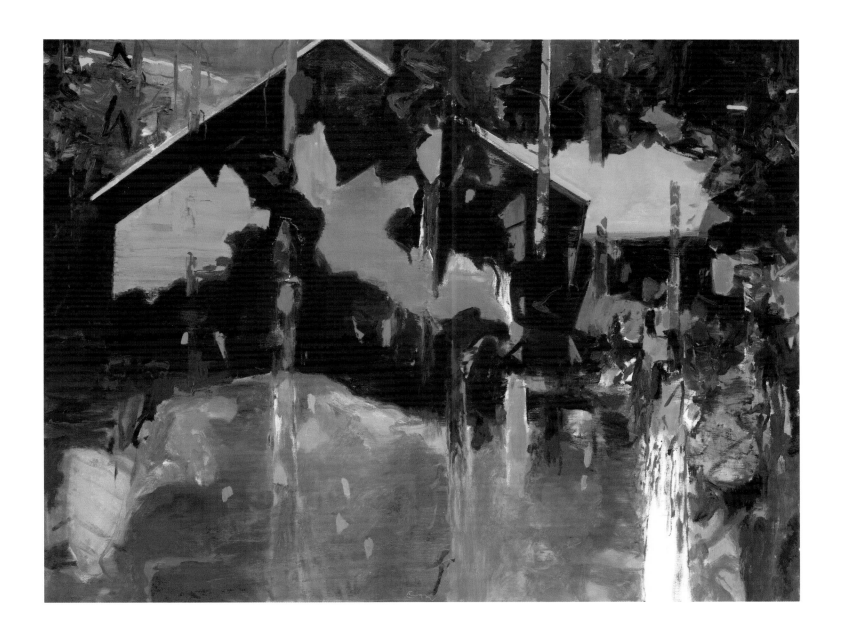

Hemlock Ravine, 2013

Oil on linen, 60 x 48 inches

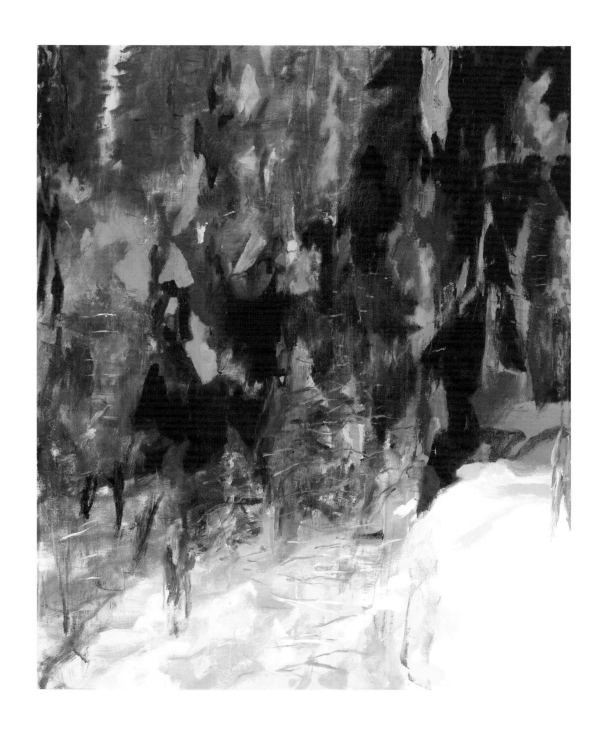

Lynx, 2013

Oil on linen, 60 x 48 inches

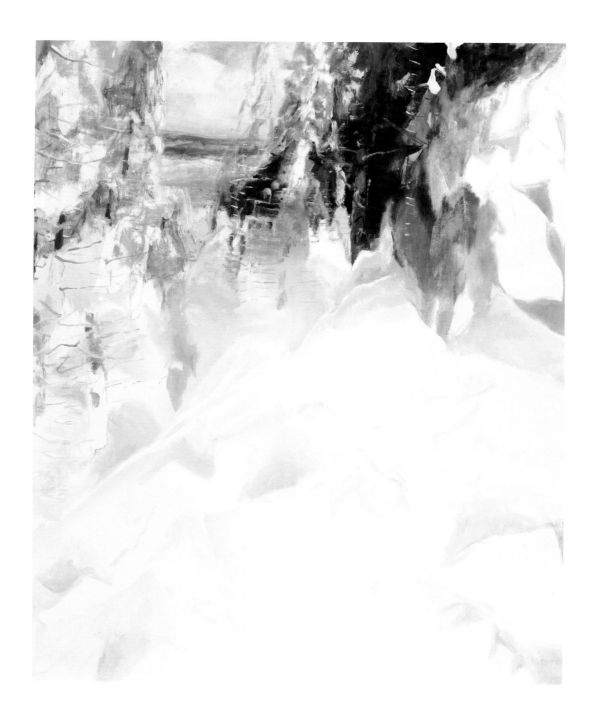

French Forest, 2012
Oil on linen, 52 x 48 inches

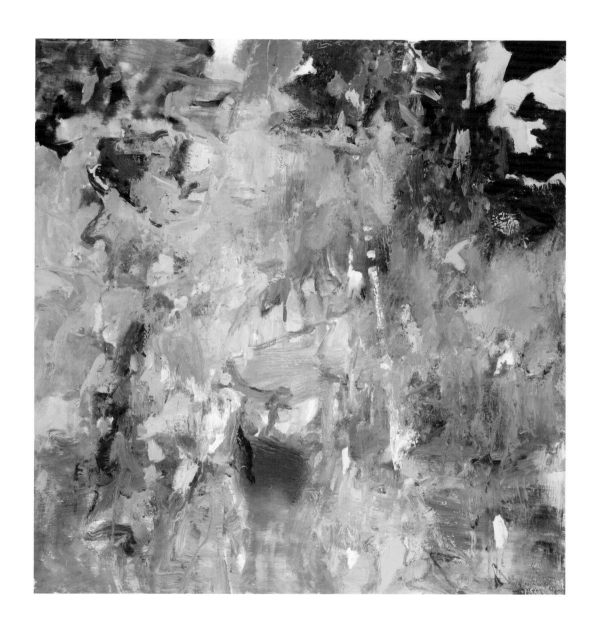

The Straw Field, 2013

Oil on linen, 48 x 52 inches

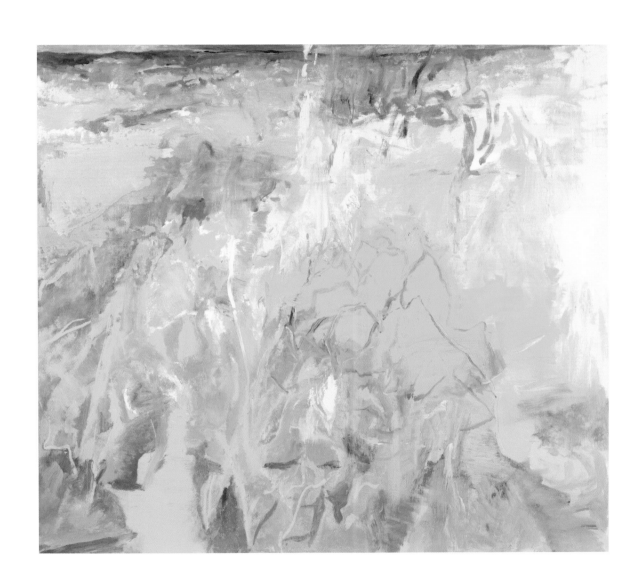

The Straw Field (detail), 2013

Oil on linen, 48 x 52 inches

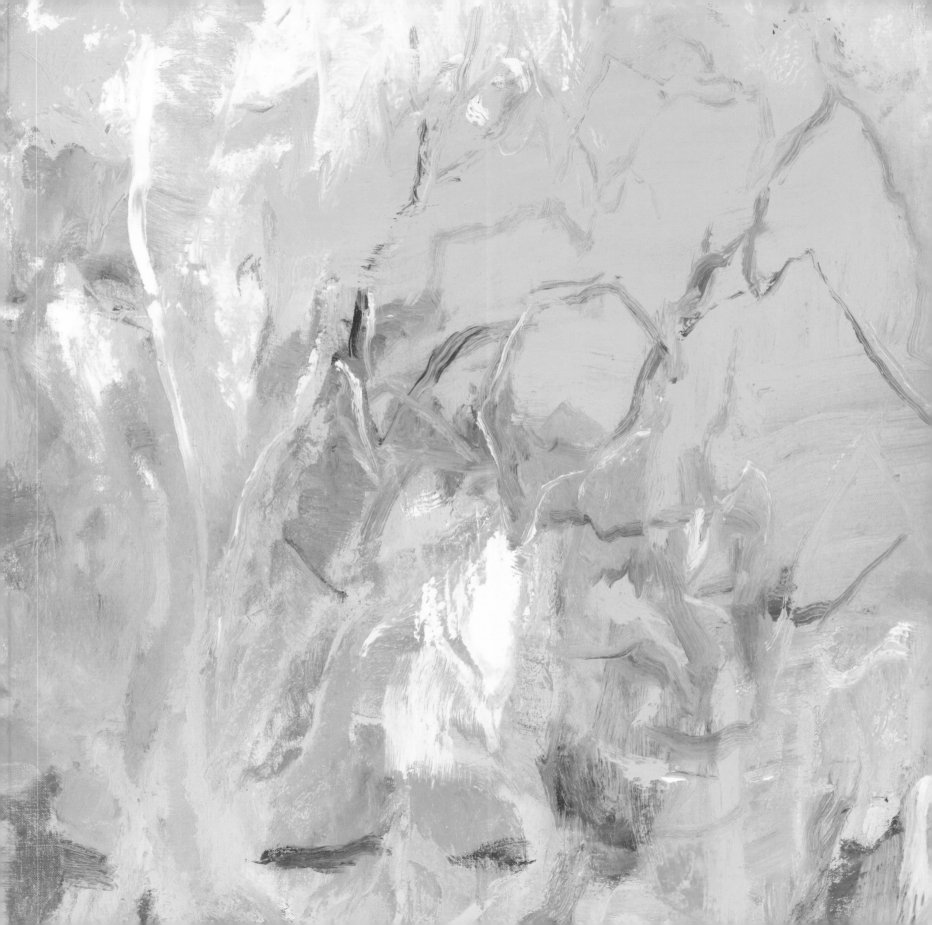

Son, 2013

Oil on linen, 48 x 60 inches

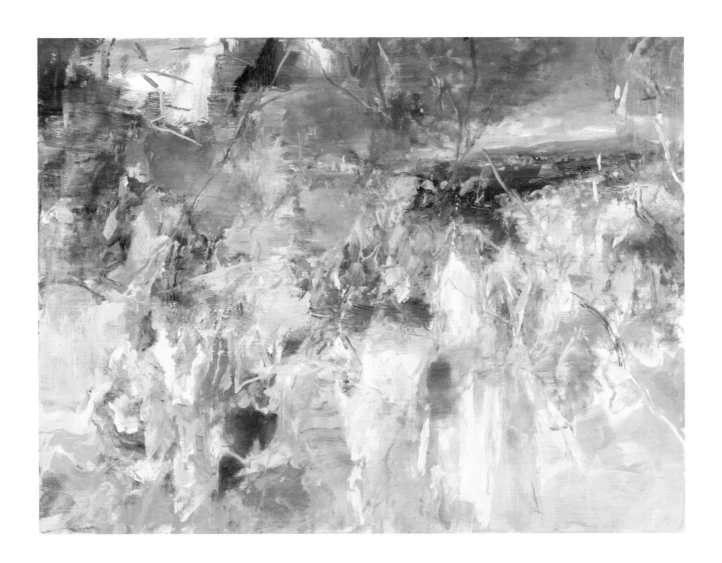

Translation, 2013
Oil on linen, 48 x 60 inches

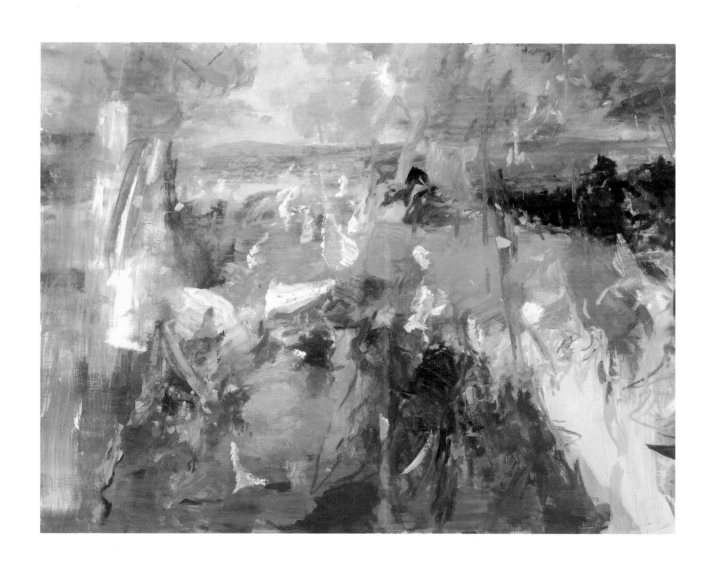

Ptarmigan, 2013
Oil on linen, 48 x 60 inches

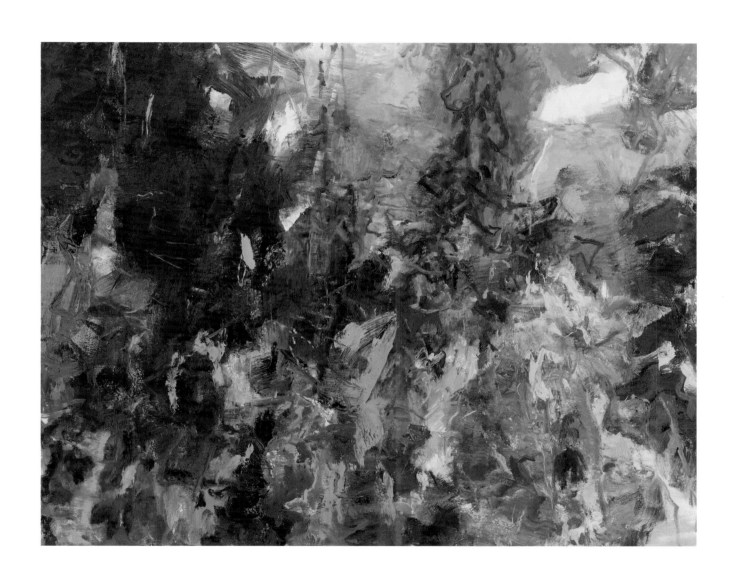

March, 2012

Oil on linen, 52 x 48 inches

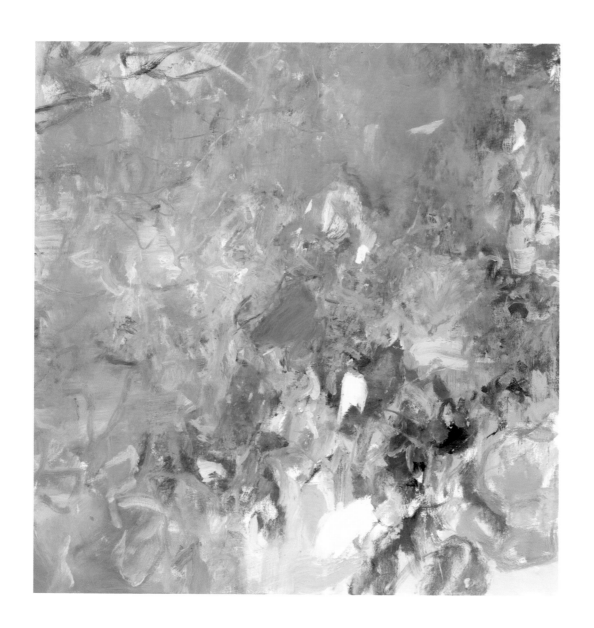

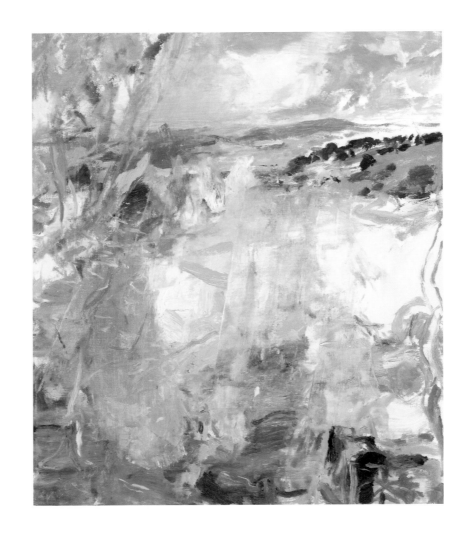

Spanish Guest, 2013
Oil on linen, 36 x 30 inches

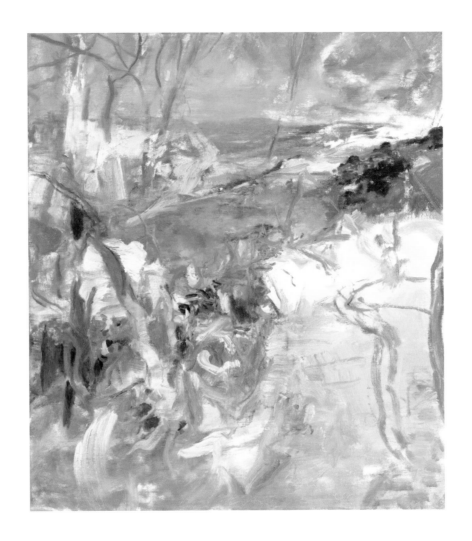

Antonello, 2013
Oil on linen, 36 x 30 inches

Trivaux, 2012
Oil on linen, 36 x 30 inches

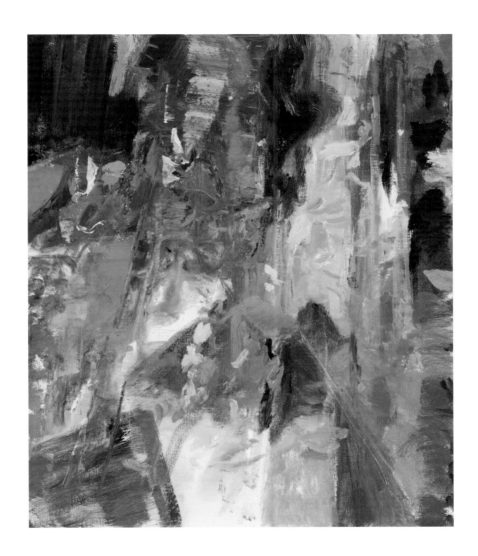

Ravine Pool, 2013
Oil on linen, 60 x 48 inches
(detail following)

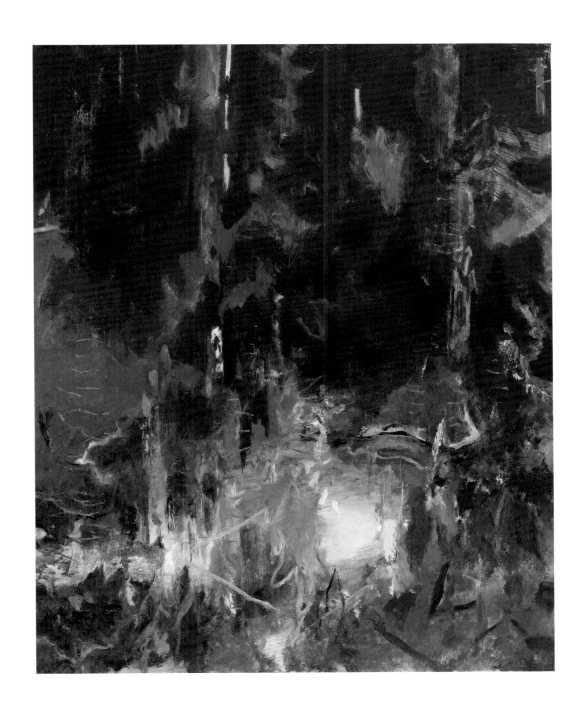

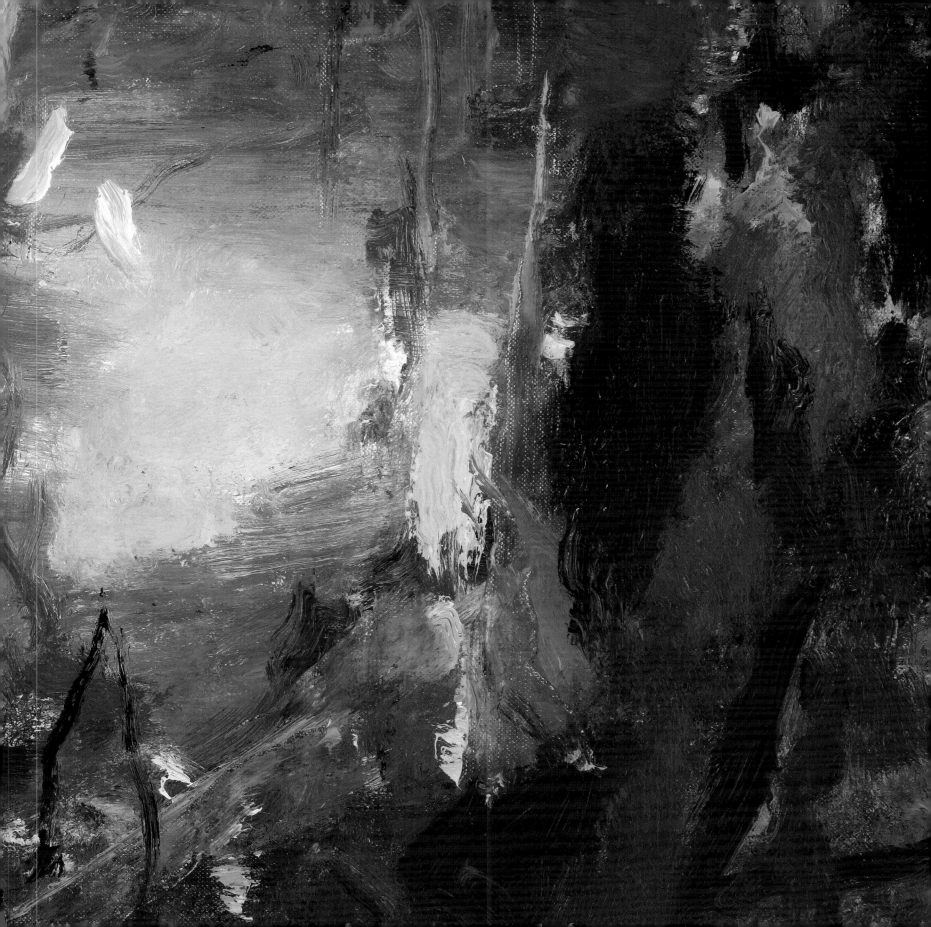

BIOGRAPHY

Born 1966, Melrose, MA

Education

1984–88 BFA, Massachusetts College of Art, Boston, MA

1986–87 Diploma, Advanced Studies in Printmaking, Central School of Art and Design, London, United Kingdom

1988–89 Graduate study, Instituto Superior de Arte, Havana, Cuba; Massachusetts College of Art, Boston, MA

1991–92 Postgraduate certificate, Institute of Art and Design, Lahti, Finland

Solo Exhibitions

2013 *Eric Aho: In the Landscape*, Federal Reserve Board, Washington, DC

Eric Aho: Translation, DC Moore Gallery, New York, NY

2012 *Transcending Nature: Paintings by Eric Aho*, Currier Museum of Art, Manchester, NH

2011 *Eric Aho: Covert*, DC Moore Gallery, New York, NY

2010 *Occurrence*, Tory Folliard Gallery, Milwaukee, WI

Eric Aho: Memory and Invention, Hidell Brooks Gallery, Charlotte, NC

2009 *Eric Aho: Red Winter*, DC Moore Gallery, New York, NY

Eric Aho: Ice Box, Brattleboro Museum & Art Center, VT

2008 *Wilderness*, Alpha Gallery, Boston, MA

Outermost, Brick Walk Fine Art, West Hartford, CT

2007 *Quarry*, Reeves Contemporary, New York, NY

New Paintings, Tory Folliard Gallery, Milwaukee, WI

2006 *The Becoming Line: Pastel Drawings*, Brick Walk Fine Art, West Hartford, CT

Copper Field Suite: New Monotypes, Center for Contemporary Printmaking, Norwalk, CT

Geography IV, Alpha Gallery, Boston, MA

Paintings, Hidell Brooks Gallery, Charlotte, NC

2005 *New Paintings*, Reeves Contemporary, New York, NY

Paintings, Tory Folliard Gallery, Milwaukee, WI

Monotypes, Devin Borden Hiram Butler Gallery, Houston, TX

2004 *Paintings*, Spheris Gallery, Bellows Falls, VT

New Paintings, Alpha Gallery, Boston, MA

Texas Papers, Devin Borden Hiram Butler Gallery, Houston, TX

2003 *The Overstory*, Reeves Contemporary, New York, NY

Paintings, Gallery BE'19, Helsinki, Finland

Recent Work, Paesaggio Gallery, West Hartford, CT

The Overhead Lake: New Paintings, Hargate Art Center, St. Paul's School, Concord, NH. Traveled to: Tremaine Gallery, Hotchkiss School, Lakeville, CT

2002 *New Paintings*, Munson Gallery, Santa Fe, NM

Watershed: Paintings of the Connecticut River Valley, Saint-Gaudens National Historic Site, Cornish, NH

Distances: Paintings of New England and Ireland, Alpha Gallery, Boston, MA

2001 *Three Counties*, Spheris Gallery, Walpole, NH

The River, Field and Sky: New Paintings, Susan Conway Gallery, Washington, DC

2000 *Standing Still, New Paintings*, Munson Gallery, Santa Fe, NM

Pure Geography, Barton-Ryan Gallery, Boston, MA

1999 *The Distant Landscape: New Paintings*, Spheris Gallery, Walpole, NH

New Helsinki Views, Galleria Pintura, Helsinki, Finland

A Passion for Winter: The Landscapes of Eric Aho, Susan Conway Gallery, Washington, DC

1998 *Recent Paintings*, Spheris Gallery, Walpole, NH

The Qualities of Heaven and Earth, Oulu City Art Museum, Finland. Traveled to: T.W. Wood Gallery & Arts Center, Vermont College, Montpelier, VT; Embassy of Finland, Washington, DC

1996 *Nocturnes: Recent Paintings by Eric Aho*, Robert Hull Fleming Museum, University of Vermont, Burlington, VT

1995 Oulu City Art Museum, Finland

Robert Hull Fleming Museum, University of Vermont, Burlington, VT

1994 *Paintings*, Gallery Pelin, Helsinki, Finland

1991 *Paintings from the Hemlock Ravine*, Tyler Gallery, Marlboro College, VT

1989 Fototeca de Cuba, Ministry of Culture, Havana, Cuba

Selected Group Exhibitions

2013 *Recent Acquisitions*, National Academy Museum, New York, NY

Woods, Lovely, Dark, and Deep, DC Moore Gallery, New York, NY

Landscape Expressed, Danforth Art Museum, Framingham, MA

Contemporary Works from the Permanent Collection, Ogunquit Museum of American Art, ME

Contemporary Voices From Vermont, Robert Hull Fleming Museum, University of Vermont, Burlington, VT

2012 *The New Members Exhibition*, The Century Association, New York, NY

Galvanized Truth: A Tribute to George Nick, The Art Complex Museum, Duxbury, MA

The Annual: 2012, National Academy Museum, New York, NY

2011 *Land Use/Misuse: The Celebration and Exploitation of the American Landscape*, Gerald Peters Gallery, Santa Fe, NM

A Sense of Place: Landscapes from Monet to Hockney, Museum of Fine Arts, Boston, MA and Bellagio Gallery, Las Vegas, NV

2010 *Changing Soil: Contemporary Landscape Painting*, Nagoya/Boston Museum of Fine Arts, Nagoya, Japan

Behind the Green Door, DNA Gallery, Provincetown, MA

Raw State, 222 Shelby Street Gallery, Santa Fe, NM

Beyond Sublime: Changing Nature, Walton Art Center, Fayetteville, AK

2009 *Trees*, DC Moore Gallery, New York, NY

Northern (L)attitudes: Norwegian and American Contemporary Art, The American-Scandinavian Foundation, New York, NY

2008 *Evening Light*, DC Moore Gallery, New York, NY

Selections from the Permanent Collection, Ogunquit Museum of American Art, ME

2007 DNA Gallery, Provincetown, MA

2006 DNA Gallery, Provincetown, MA

The 181st Annual: Exhibition of Contemporary American Art, National Academy Museum, New York, NY

HotPics06, Katonah Museum of Art, NY

Invitational Exhibition of Painting and Sculpture, American Academy of Arts and Letters, New York, NY

2005 *In the Zone*, Brattleboro Museum & Art Center, VT

Northern Passages, DeVos Art Museum, Northern Michigan University, Marquette, MI

Diminutive Destinations, Ogunquit Museum of American Art, ME

2004 *Contemporary Views of the Landscape*, Colby Sawyer College, New London, NH

2003 *2003 Portland Museum of Art Biennial*, Portland Museum of Art, ME

Éire/Land, McMullen Museum of Art, Boston College, Chestnut Hill, MA

Ballinglen: The Artist in Rural Ireland, Castlebar Art Centre, County Mayo, Ireland

2002 *The American River*, Brattleboro Museum & Art Center, VT. Traveled to: T.W. Wood Gallery & Arts Center, Vermont College, Montpelier, VT; Philadelphia Art Alliance, PA; Florence Griswold Museum, Lyme, CT

George Nick Selects, Concord Art Association, MA

Recent Acquisitions, Achenbach Foundation for Graphic Arts, Fine Arts Museum of San Francisco, CA

2001 *Plain Air: Eric Aho, Lois Dodd, Wolf Kahn, Emily Nelligan, Stuart Shils*, Paesaggio Gallery, West Hartford, CT

2000 *175th Annual Exhibition*, National Academy Museum, New York, NY

1999 *Ultima Thule*, University of Lapland, Rovaniemi, Finland

1998 *173rd Annual Exhibition*, National Academy Museum, New York, NY

1997 *William Lumpkins and Eric Aho*, Munson Gallery, Santa Fe, NM

1996 *Small-Scale Landscapes*, Bernard Toale Gallery, Boston, MA

Views from Vermont: Works from the Permanent Collection, Robert Hull Fleming Museum, University of Vermont, Burlington, VT

Weir Farm Visiting Artists, Aldrich Museum of Contemporary Art, Ridgefield, CT

New England /New Talent, Fitchburg Art Museum, MA

Provincetown Artists, Provincetown Art Association and Museum, MA

1995 *Small Works*, Rubicon Gallery, Dublin, Ireland

Landscapes, Thomas Segal Gallery, Boston, MA

1994 *Regional Selections 1994*, Hood Museum of Art, Dartmouth College, Hanover, NH

1992 *Young Talent Show*, Washington Art Association, Washington Depot, CT

1991 *Boston Drawing Show*, Boston Center for the Arts, MA

1990 *Regional Exhibition*, Fitchburg Art Museum, MA

1989 *From Havana*, Santa Clara Museum of Art, Cuba

1988 *Young Printmakers from the U.S.*, University of Cape Town, South Africa

Selected Bibliography

2013 Tuite, Diana. "Painting Close In," *Eric Aho: Translation* (exh. cat.), New York, NY: DC Moore Gallery.

"Woods, Lovely, Dark and Deep," *Wall Street International Magazine*.

Della Monica, Lauren P. *Painted Landscapes: Contemporary Views*, Atglen, PA: Schiffer.

2012 Distler, Arlene. "Not Tyrannized by the Seen," *Art New England Online*, October 24.

Smee, Sebastian. "Editor's Pick: Transcending Nature: Paintings by Eric Aho," *The Boston Globe*, August 15.

McQuaid, Cate. "Tribute to George Nick, a painter and teacher with heart," *The Boston Globe*, July 30.

Beem, Ed. "Eric Aho Breaks Down the New England Landscape," *Yankee Magazine*, July 18.

Kuechenmeister, Mary and Eric Aho. "Inspired Lives: Eric Aho," *New Hampshire News* Recorded July 11. NHPR Radio.

McQuaid, Cate. "Contemporary painters bring dynamism, drama to N.E. landscapes," *The Boston Globe*, July 17.

Chestney, Linda. "Transcending Nature: Paintings by Eric Aho," *Artscope*, July 17.

Aucoin, Dan. "Transcending Nature: Paintings by Eric Aho," *The Boston Globe*, June 13.

"Summer Arts Preview: Transcending Nature: Paintings by Eric Aho," *The Boston Globe*, May 20.

Spahr, P. Andrew, Bruce McColl, and Chard deNiord.

Transcending Nature: Paintings By Eric Aho (exh. cat.), Manchester, NH: Currier Museum of Art.

2011 Huebner, Jeff. *Trees, Rocks and Water: The Finnish-ness in American Art* (exh. cat.), Hancock, MI: Finlandia University Gallery.

Wei, Lilly. "Eric Aho: DC Moore," *ARTnews*, December.

"Exhibition at DC Moore Gallery of new paintings by Eric Aho explore the idea of the covert," *ArtDaily.org*, September 10.

Kuspit, Donald. "Sublime Fullness, Perennial Light: Eric Aho's Paintings," *Eric Aho: Covert* (exh. cat.), New York, NY: DC Moore Gallery.

2010 Inokuchi, Satoko. *Changing Soil: Contemporary Landscape Painting* (exh. cat.), Nagoya, Japan: Nagoya/Boston Museum of Fine Arts.

Packard, Andrea. *Beyond Sublime: Changing Nature* (exh. cat.), Fayetteville, AK: Walton Arts Center.

Aho, Eric. "Eric Aho Puts Five Questions to Ellen Altfest," *Modern Painters*, April.

Dorrill, Lisa. "Fire and Ice: The Sublime Landscapes of Eric Aho," *The Gettysburg Review*, Spring.

2009 Guyon, Anne Lawrence. "Eric Aho. DC Moore," *Art in America*, December.

Costello, Bonnie. "Red Winter: Eric Aho's Actuality," *Eric Aho: Red Winter* (exh. cat.), New York, NY: DC Moore Gallery.

Smee, Sebastian. "Maine Event," *The Boston Globe*, May 8.

Beem, Edgar Allen. "HOME at Westport Arts Center, Painter Eric Aho creates a homecoming," *Yankee Magazine*, May.

2008 McQuaid, Cate. "A See Change in 2008," *The Boston Globe*, December 24.

McQuaid, Cate. "The Elements Beyond Our Control," *The Boston Globe*, May 21.

2007 Campion, Peter. *Quarry* (exh. cat.), New York, NY: Reeves Contemporary.

McQuaid, Cate. "On the Surface and Beneath," *The Boston Globe*, August 30.

2006 Guyon, Anne Lawrence. "Fresh Paint Breathes Venerated Air," *Rutland Herald*, November 16.

Kirk, Anthony. *Copper Field Suite* (exh. cat.), Norwalk, CT: Center for Contemporary Printmaking.

The Becoming Line: Pastel Drawings (exh. cat.), West Hartford, CT: Brick Walk Fine Art.

Kadour, Ric Kasini. "Eric Aho," *Art New England*, February/March.

McQuaid, Cate. "Provincetown's Visual Landscape," *The Boston Globe*, August 17.

2005 Slayton, Tom. "The Big Evocative Landscapes of Eric Aho," *Vermont Life*, Summer.

Vendler, Helen. *Eric Aho: New Paintings* (exh. cat.), New York, NY: Reeves Contemporary.

2004 Sherman, Michael, Gene Sessions, and P. Jeffrey Potash. *Freedom and Unity: A History of Vermont*, Barre, VT: Vermont Historical Society.

2003 Vendler, Helen. *The Overstory* (exh. cat.), New York, NY: Reeves Contemporary.

Uimonen, Anu. "Myrsky nousee Keiteleen ylle," *Helsingin Sanomat*, October 16.

Conley, Alston. *Éire/Land* (exh. cat.), Chestnut Hill, MA: McMullen Museum of Art, Boston College.

2002 Sieker, Don. "Eric Aho, Watershed: Paintings of the Connecticut River Valley," *Art New England*, December.

Arthur, John. *Eric Aho: New Paintings* (exh. cat.), Santa Fe, NM: Munson Gallery.

Beem, Edgar Allen. "Six to Watch," *Yankee Magazine*, September.

Haas, Robert, and Carl Belz. *The American River:*

National Exhibition (exh. cat.), Walpole, NH: Great
River Arts Institute.

2001 Shannon, Joe. "Eric Aho at Susan Conway Gallery," *Art in
America*, September.

Tarbell, Bethany. "Studio Session: The Sky's the Limit,"
Art and Antiques, September.

2000 Waterman, Jill. "Tranquil Vistas Among Skyscrapers,"
ArtsMedia, March.

1999 Smith, Robert F. "Recent Paintings at Spheris Gallery,"
ARTnews, February.

Protzman, Ferdinand. "Eric Aho at Susan Conway
Gallery," *The Washington Post*, March 11.

1998 deNiord, Chard. *The Qualities of Heaven and Earth* (exh.
cat.), Oulu, Finland: Oulu City Art Museum.

Driscoll, John. *The Artist and the American Landscape*,
Cobb, CA: First Glance Books, Inc.

Fellowships and Residencies

1997–2004 Returning Fellowship, Ballinglen Arts Foundation,
Ballycastle, County Mayo, Ireland

1995 Artist in Residence, Weir Farm National Historic Site,
Wilton, CT

Artist Fellowship, Ballinglen Arts Foundation, Ballycastle,
County Mayo, Ireland

1994 Individual Artist's Fellowship, Vermont Council on the
Arts, Montpelier, VT

1991–92 Fulbright Fellowship, Institute of International Education,
New York, NY

Grants and Awards

2009 Elected National Academician, National Academy
Museum, New York, NY

2003 The American-Scandinavian Foundation, New York, NY

2000 The John Koch Award for Painting, American Academy of
Arts and Letters, New York, NY

1998 Julius Hallgarten Prize, National Academy of Design, New
York, NY

1997 Vermont Arts Council and the National Endowment for
the Arts, Montpelier, VT

Finlandia Foundation, Los Angeles, CA

1994 The Pollock-Krasner Foundation Inc., New York, NY

Vermont Community Foundation, Middlebury, VT

1993 The American-Scandinavian Foundation, New York, NY

Selected Public Collections

The Art Complex Museum, Duxbury, MA
Ballinglen Arts Foundation, Ballycastle, County Mayo, Ireland
Boston Public Library, MA
Dartmouth College, Hanover, NH
Federal Reserve Bank of Boston, MA
Fine Arts Museums of San Francisco, CA
Robert Hull Fleming Museum, University of Vermont, Burlington, VT
The Metropolitan Museum of Art, New York, NY
Ministry of Culture, Havana, Cuba
Museum of Fine Arts, Boston, MA
National Academy Museum, New York, NY
National College of Art, Oslo, Norway
The New York Public Library, NY
Ogunquit Museum of American Art, ME
Oulu Museum of Art, Finland
The Provincetown Art Association and Museum, MA
Springfield Art Museum, MO
Theatre Academy Helsinki, Finland
Tufts University, Medford, MA
University of Cape Town, South Africa
Vermont State Art Collection, Montpelier, VT

Published on the occasion of the exhibition

ERIC AHO

Translation

October 10 – November 9, 2013

Copyright © DC Moore Gallery, 2013
Painting Close In © Diana Tuite, 2013
ISBN 978-0-9896416-0-9

Publications Manager: Andrea Cerbie
Design: Reed Seifer Associates
Photography: Rachel Portesi
Printed in the United States by The Studley Press

Cover: *CANADA* (detail), 2013
Oil on linen, 48 x 60 inches
Following page: *Spanish Landscape II (After Titian)*, 2013
Oil on linen, 36 x 30 inches

DC MOORE GALLERY

535 WEST 22ND STREET NEW YORK NY 10011

212.247.2111 WWW.DCMOOREGALLERY.COM

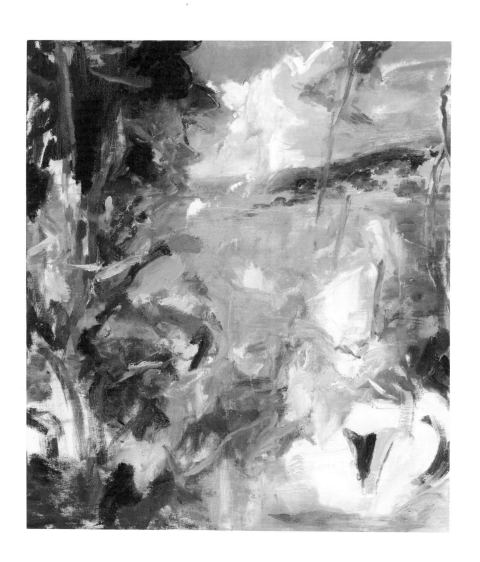